How to Draw
with Drew Brophy

Walter Foster

Illustrated by Drew Brophy
Written by Drew Brophy & Maria Brophy

Meet Drew

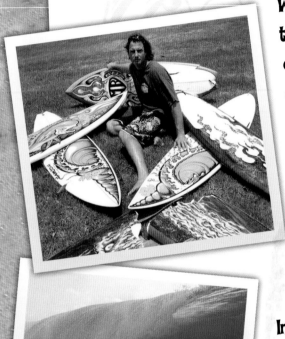

World-famous surf artist Drew Brophy has always loved to draw. When he was just 4 years old, he drew his name on his first surfboard—and that's when his love for art and surf was born.

As a kid, Drew's life was all about drawing, surfing, and skateboarding. He also learned to play the guitar, and he spent his teen years surfing and creating art and music.

In high school, Drew dreamed of surfing and traveling and then painting his experiences. But it seemed like an impossible way to make a living. One day he made a list of the things he wanted out of life. Writing his dreams down was the magic he needed to make them happen. Drew realized that he could do anything he wanted—he just had to go for it.

Drew began his art career by painting his lively drawings on surfboards. In his 20s, he became the best-known surfboard artist in the world, using techniques that he developed with water-based paint pens. The demand for his surfboards became so high that Drew started teaching his techniques to others.

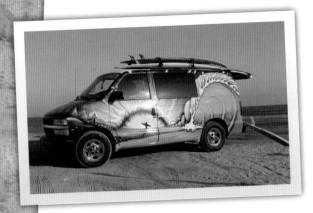

Drew then began creating art for clothes in the surf industry, which led to creating art for different products and ultimately selling paintings. Even now, Drew's job is to make things look cool. He continues to create art for everything from skateboards and wakeboards to water bottles, shoes, and guitars. Drew's unique style of art is easily recognized and often imitated, and he gets excited when his artwork inspires someone to pick up a pencil and start drawing.

Today, Drew continues to teach his techniques through workshops, instructional DVDs, and his own online show called *The Paint Shop with Drew Brophy*.

Drew loves to travel with his wife and son, exploring new surf spots all over the world. And when they return home, Drew goes back to work, painting the inspiration he picked up from his adventures. Drew's vision is to inspire generations of people to live the life of their dreams. After all, if he can do it, you can too.

Life is good!

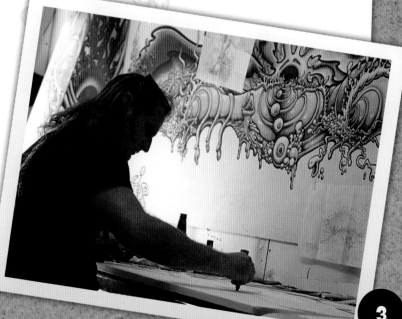

Tools & Materials

Drawing paper

Eraser

Drawing pencil

Colored pencils

Markers or acrylic paint pens

Palette

Acrylic WHITE

Acrylic MEDIUM YELLOW

Acrylic PHTHALO BLUE

Acrylic LIGHT GREEN

Acrylic PHTHALO GREEN

Acrylic BURNT UMBER

Paint

Brushes

Getting Started

In this book, I'm going to show you how to draw some of my favorite things. You can then put these drawings together to create a fantastic painting.

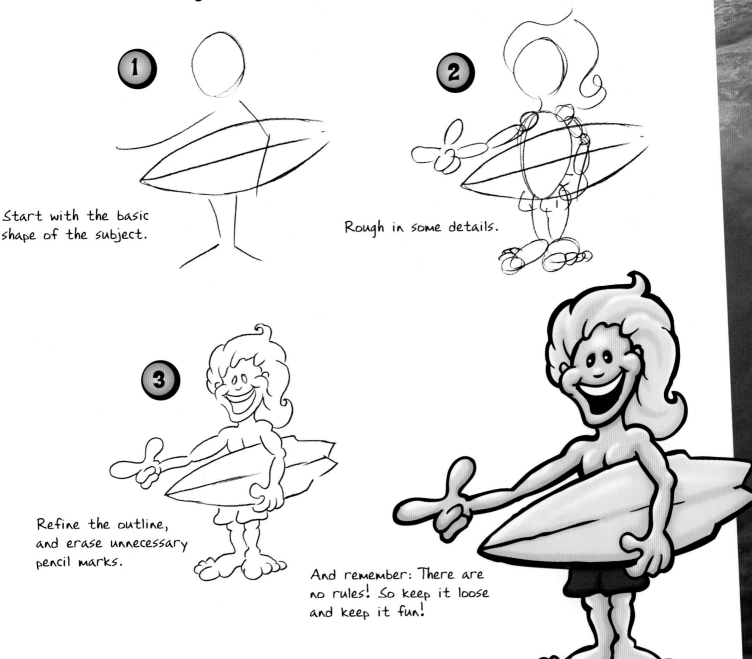

1 Start with the basic shape of the subject.

2 Rough in some details.

3 Refine the outline, and erase unnecessary pencil marks.

And remember: There are no rules! So keep it loose and keep it fun!

Coloring

Below is the basic method I use to color my drawings. You can apply this method to any of the projects in this book. I prefer coloring with paint pens because they combine the blending power of paint with the control of drawing; however, you can use acrylic paint, colored pencils, markers, paint pens, or whatever you prefer. Note: For best results when adding color to gear (see pages 44-47) or darker surfaces, use opaque paint pens.

Snail
(Project on page 27)

Begin with a clean pencil outline.

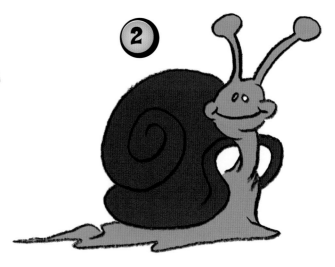

Now fill in the "midtone" color for the shell and the body. Think of the midtone as the main color, without shadows or highlights.

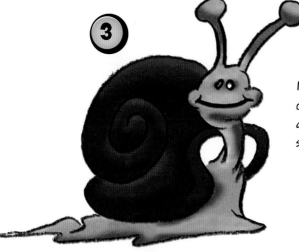

Next, add a darker pink to the shell and a darker tan to the body for shadows. Imagine a light source coming down from above, casting subtle shadows over the forms.

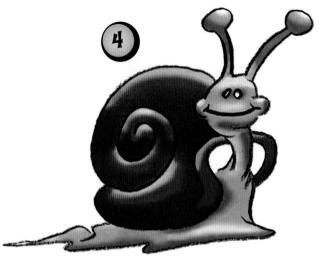

④

Give the shell and body even more form by adding highlights with white, again thinking about the direction of light. Note: If you're working with colored pencils or markers, you'll want to work around the highlights in step two. (With these tools, it's hard to recover the white of the paper!)

⑤

Trace your outlines with a solid black line, and fill in the darkest shadows with black (such as inside the shell). Then you're done!

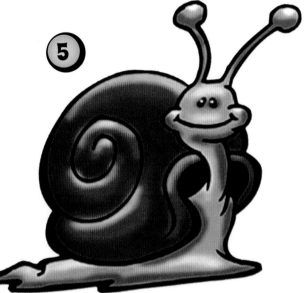

Super Tube
(Project on page 8)

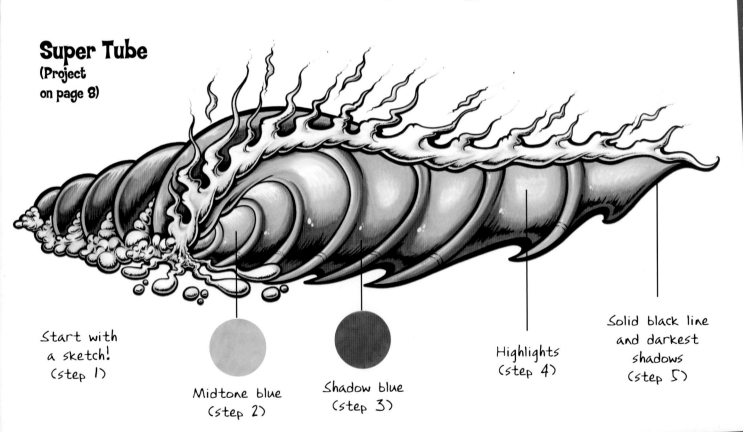

Start with a sketch! (step 1)

Midtone blue (step 2)

Shadow blue (step 3)

Highlights (step 4)

Solid black line and darkest shadows (step 5)

Super Tube

I call this the "flow line."

1

Build your wave out from the flow line, curving with the curl of the wave.

2

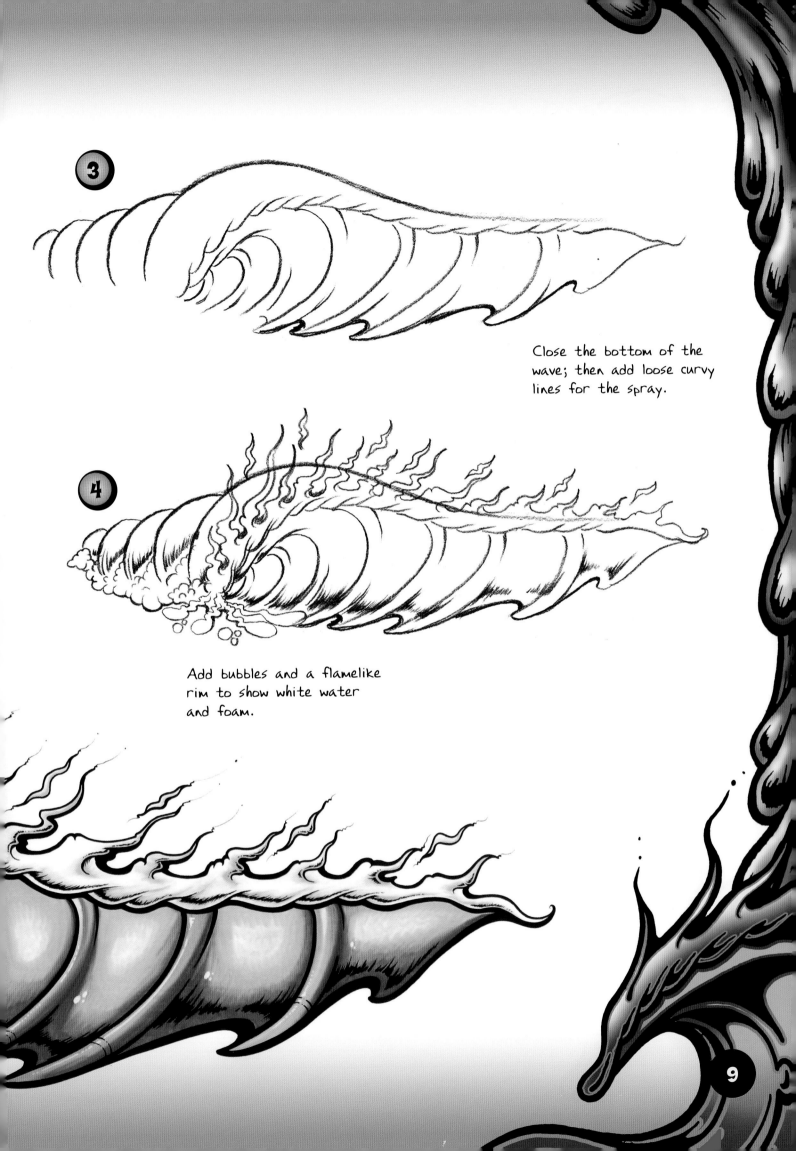

3

Close the bottom of the wave; then add loose curvy lines for the spray.

4

Add bubbles and a flamelike rim to show white water and foam.

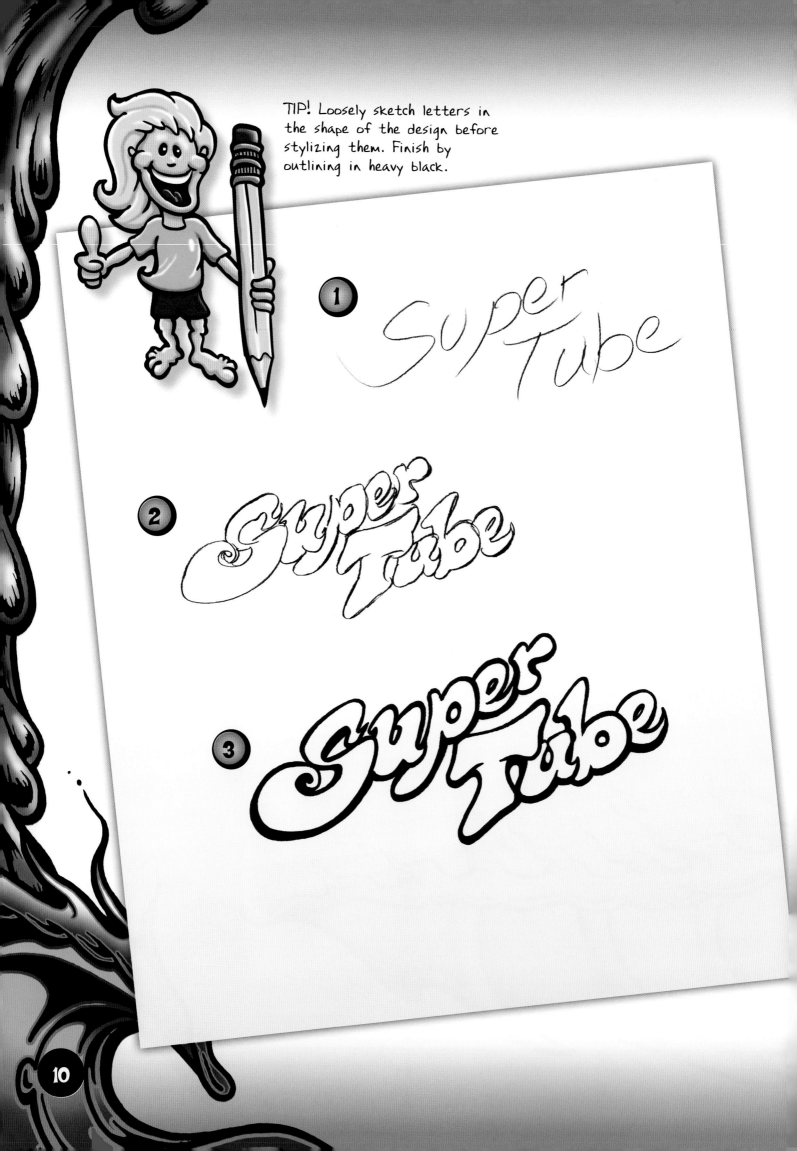

TIP! Loosely sketch letters in the shape of the design before stylizing them. Finish by outlining in heavy black.

1 Super Tube

2 Super Tube

3 Super Tube

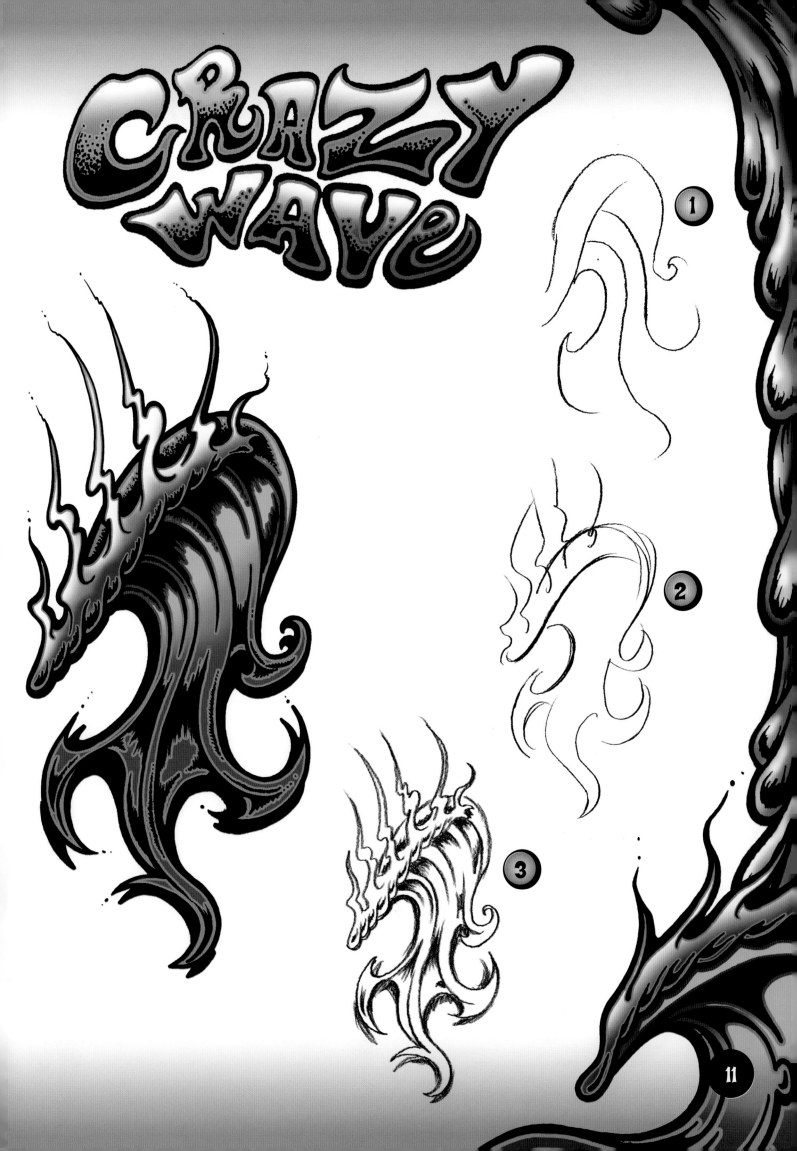

Happy Fish

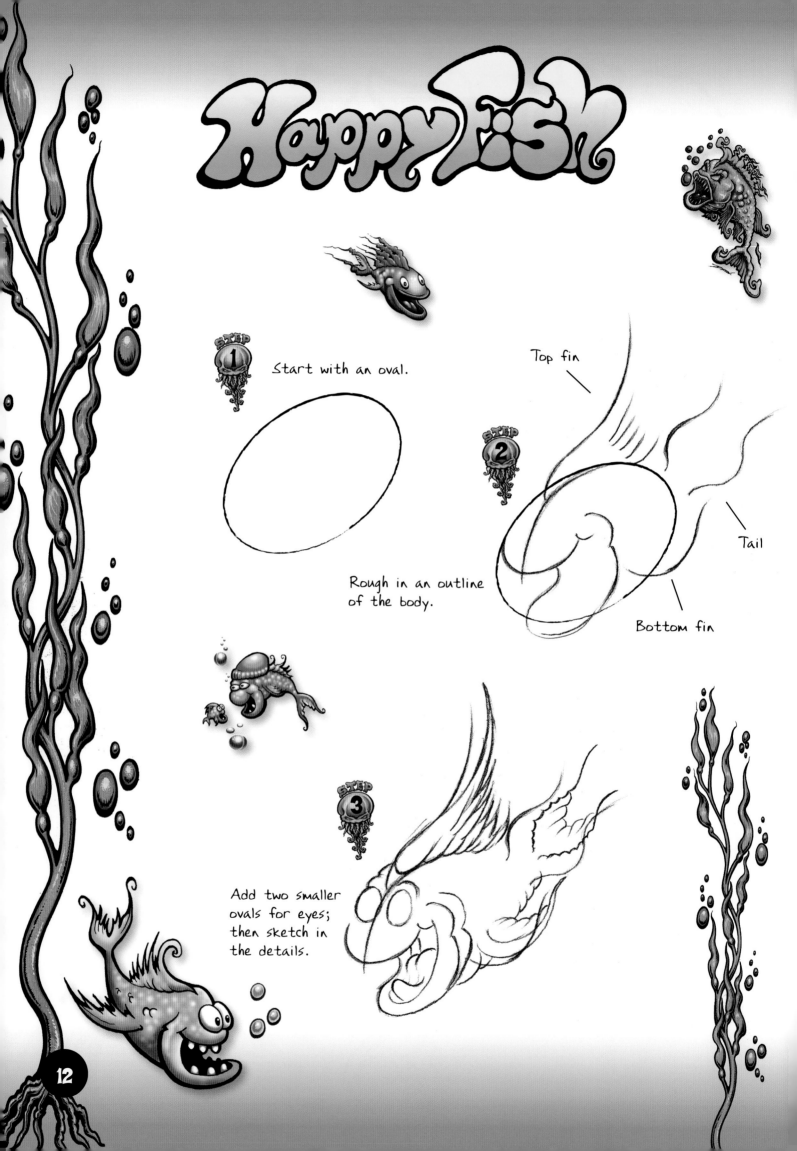

STEP 1
Start with an oval.

STEP 2
Rough in an outline of the body.

Top fin

Tail

Bottom fin

STEP 3
Add two smaller ovals for eyes; then sketch in the details.

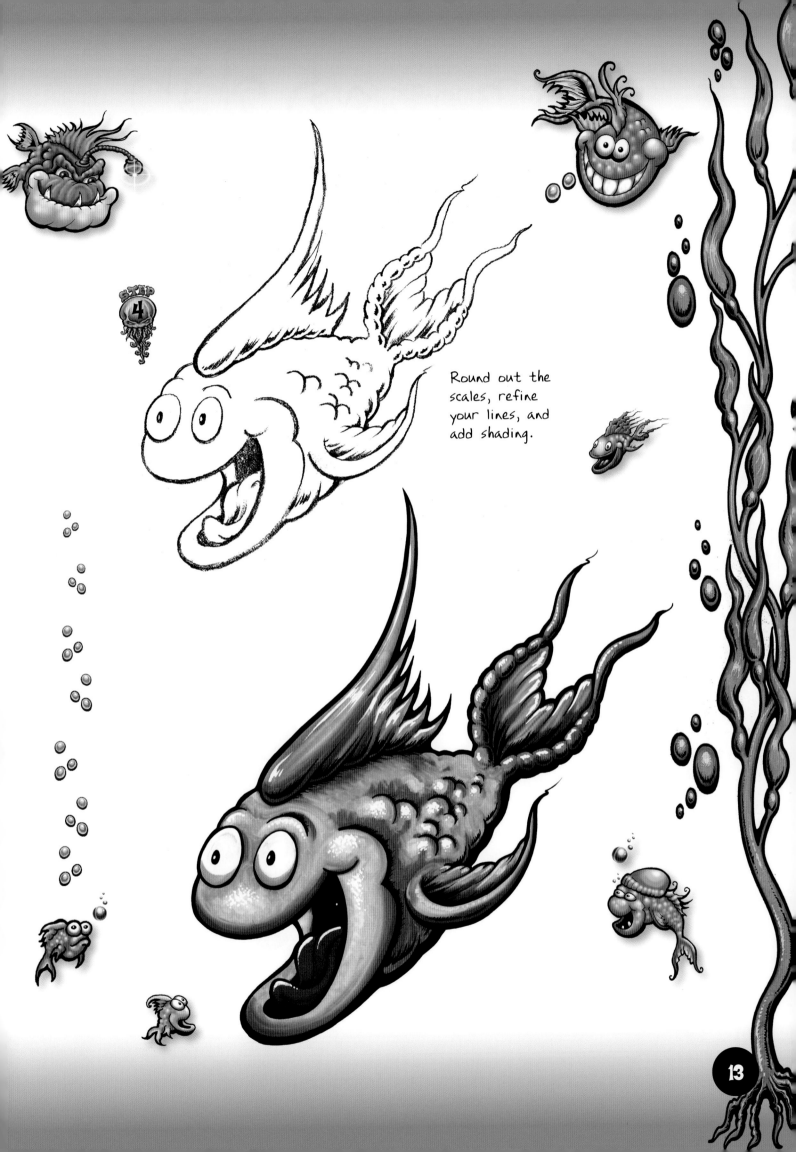

Round out the scales, refine your lines, and add shading.

STEP 4

13

Grumpy Fish

STEP 1

Start with an oval.

STEP 2

Rough in the body.

Mouth and gills

STEP 3

Continue adding the details.

STEP 4

Add spiked scales, sharp teeth, and shading.

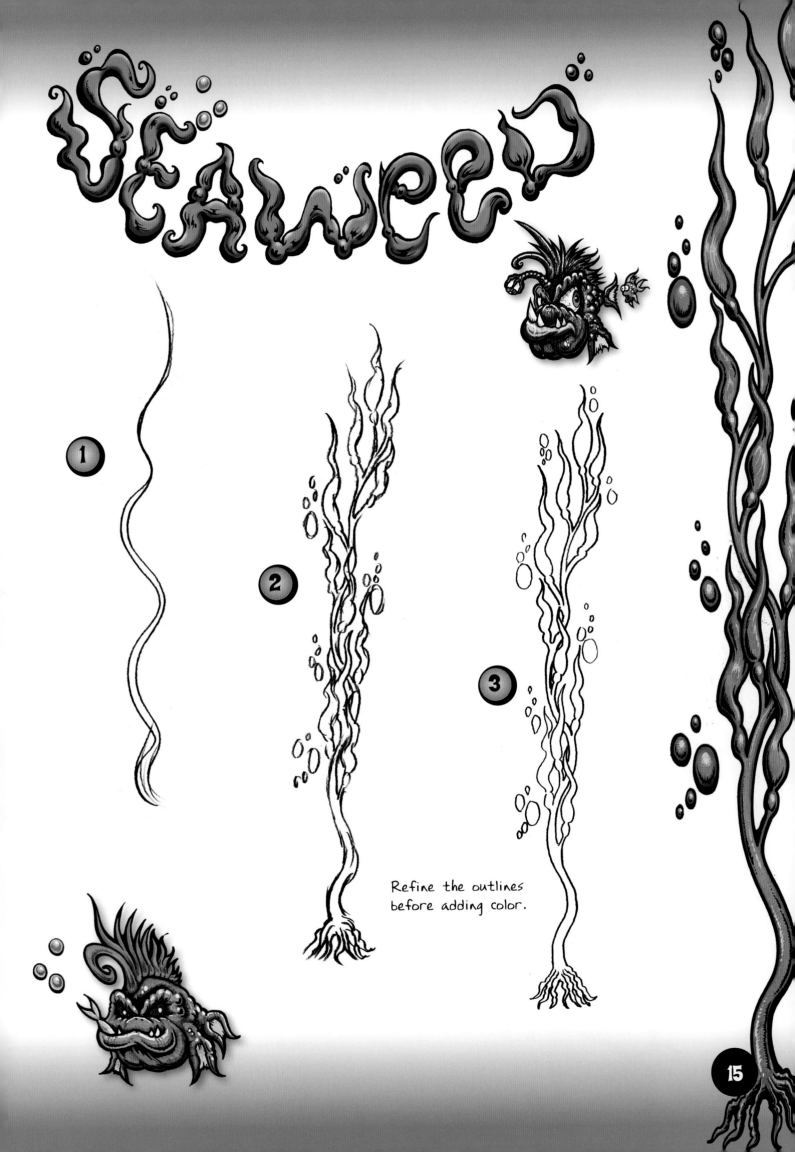

Seaweed

1

2

3

Refine the outlines
before adding color.

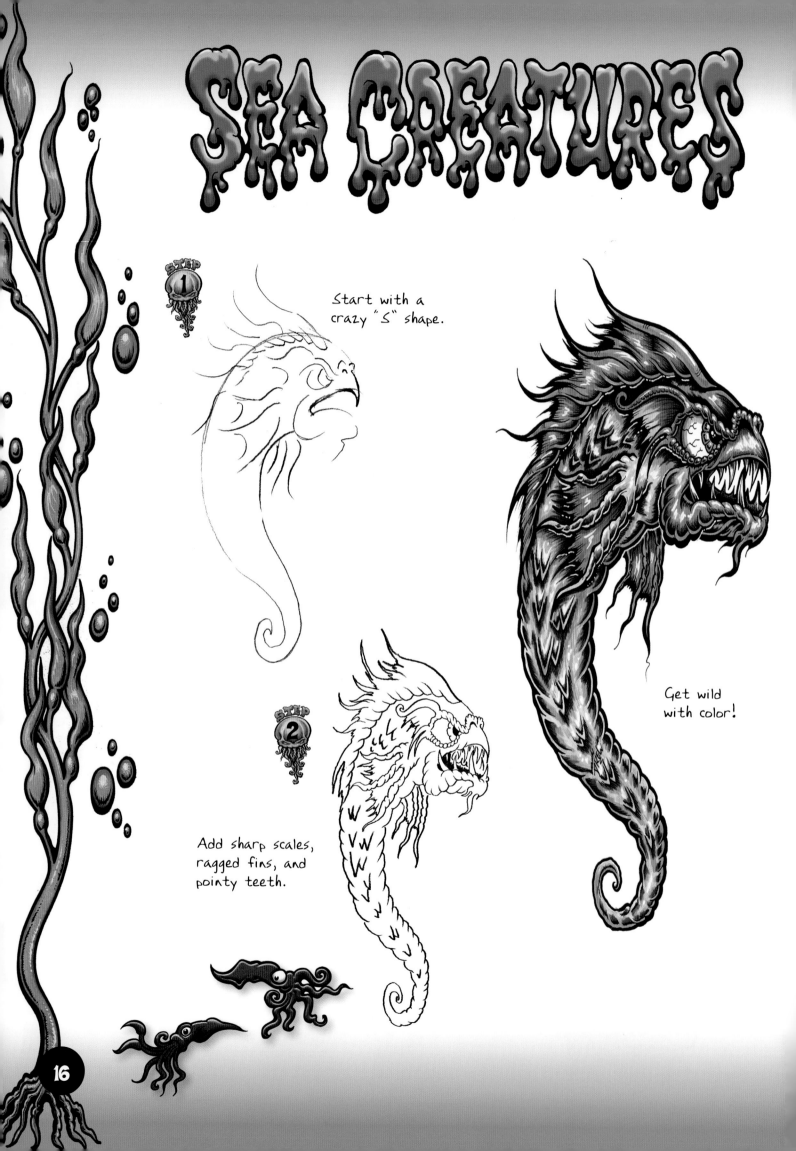

SEA CREATURES

STEP 1

Start with a crazy "S" shape.

STEP 2

Add sharp scales, ragged fins, and pointy teeth.

Get wild with color!

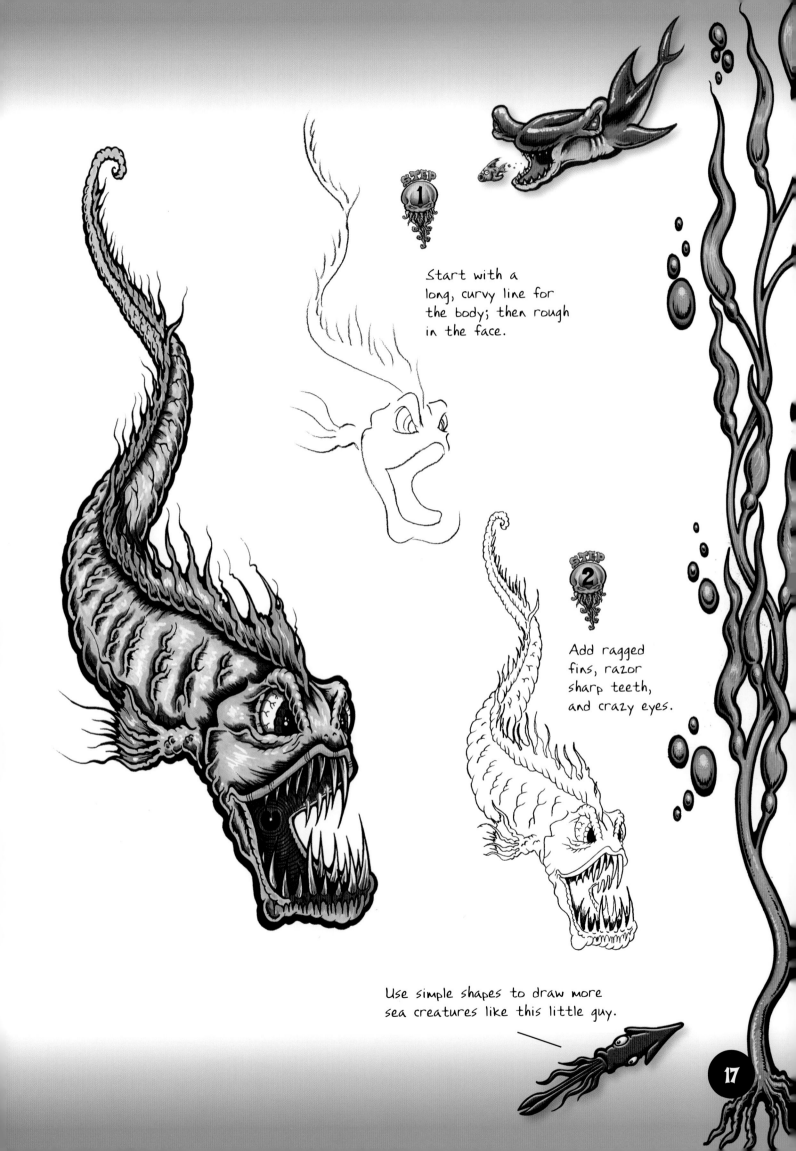

STEP 1

Start with a long, curvy line for the body; then rough in the face.

STEP 2

Add ragged fins, razor sharp teeth, and crazy eyes.

Use simple shapes to draw more sea creatures like this little guy.

1 Start with a vertical centerline. Add horizontal lines for the eyes, nose, mouth, and chin; then rough in the details.

2 Cheeks

Big mouth

3 Draw in the teeth; then finish the head and jaw. Clean up unnecessary lines before adding color.

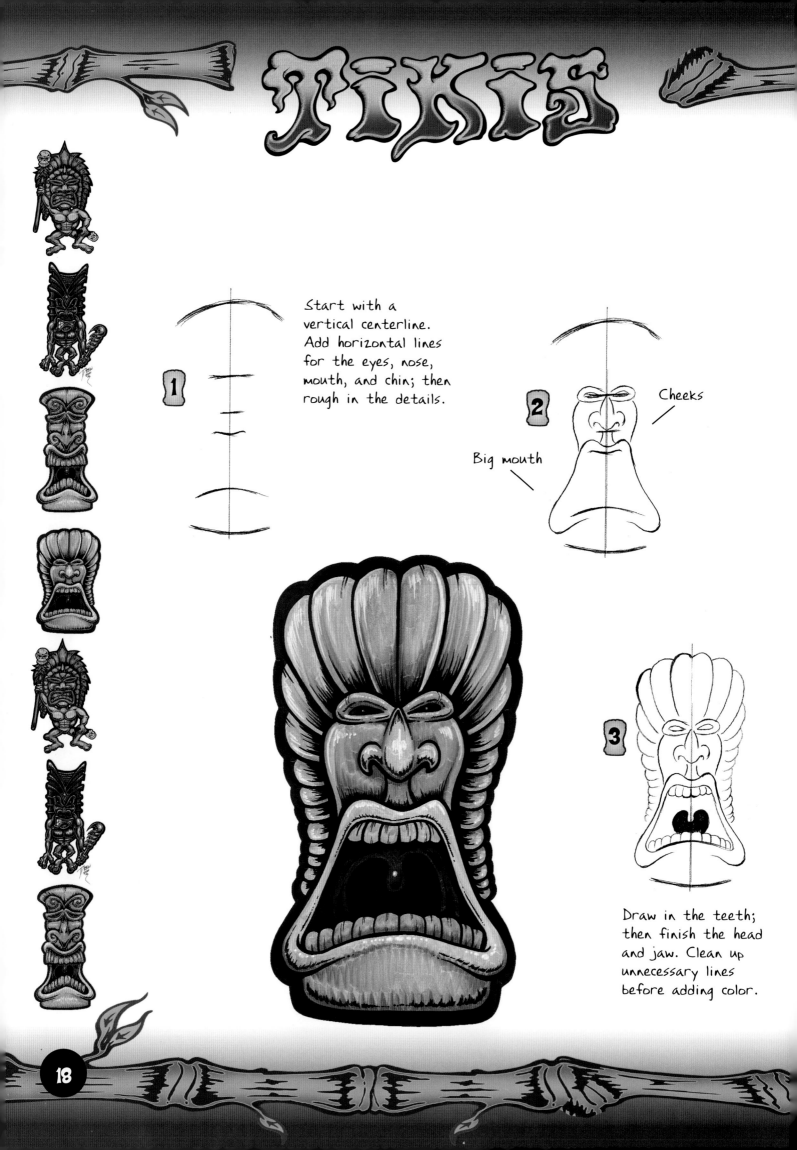

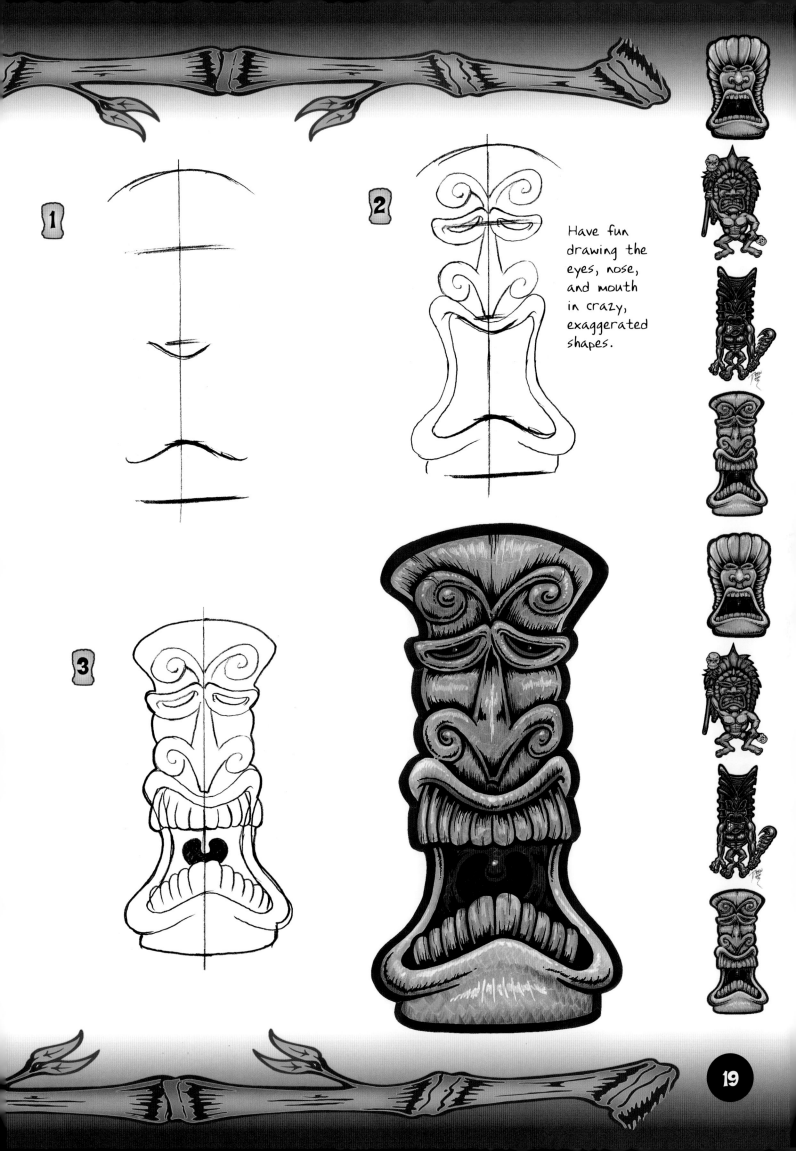

1

2

Have fun drawing the eyes, nose, and mouth in crazy, exaggerated shapes.

3

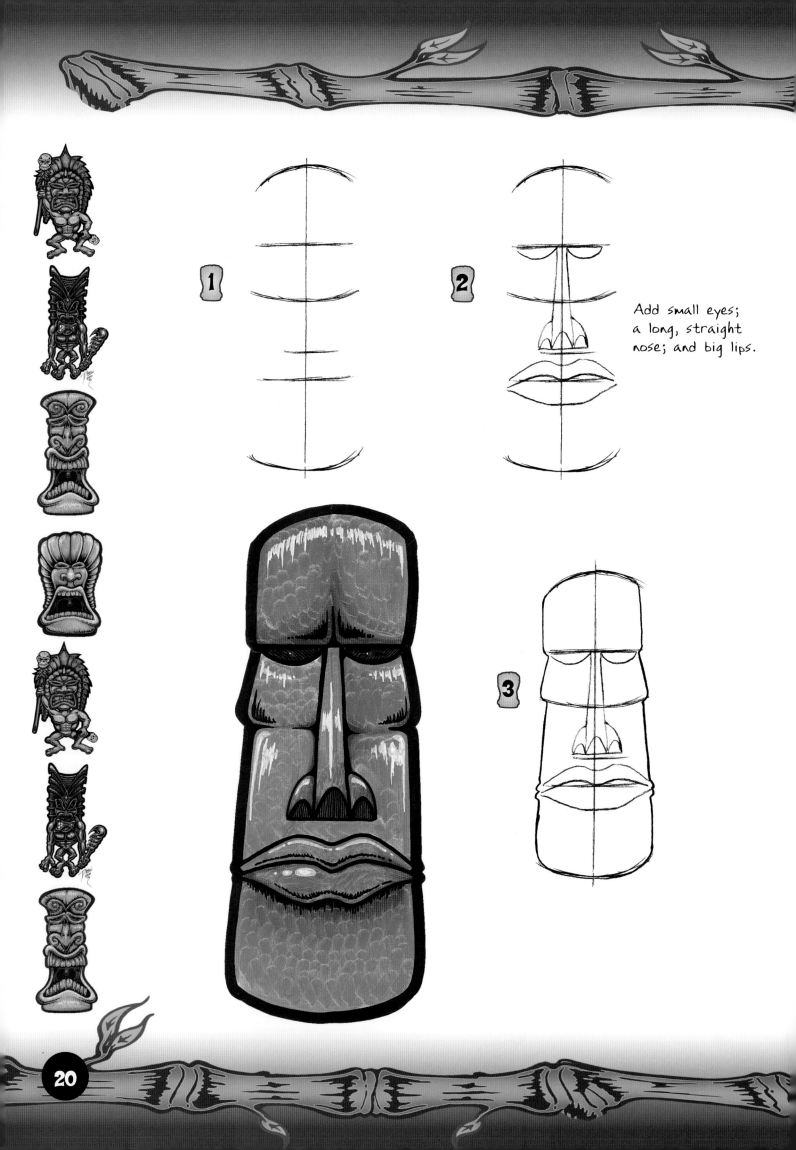

1

2

Add small eyes;
a long, straight
nose; and big lips.

3

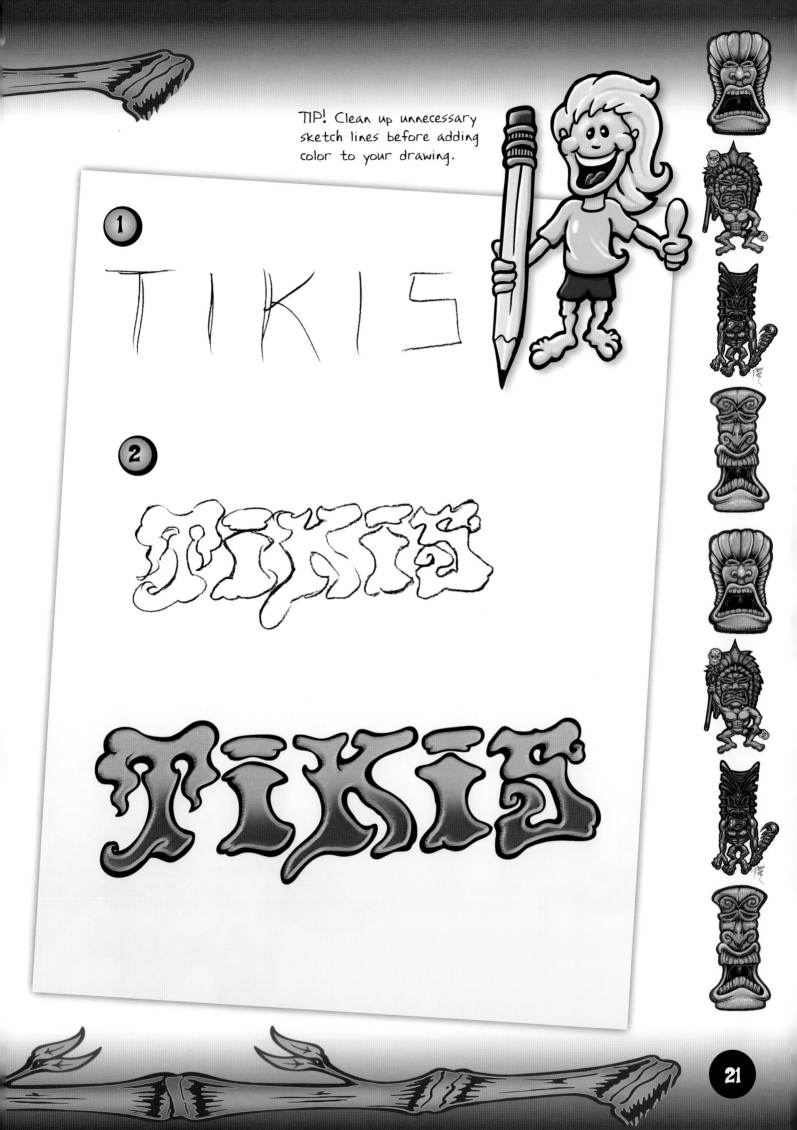

TIP! Clean up unnecessary sketch lines before adding color to your drawing.

① TIKIS

② TIKIS

TIKIS

FLOWERZ

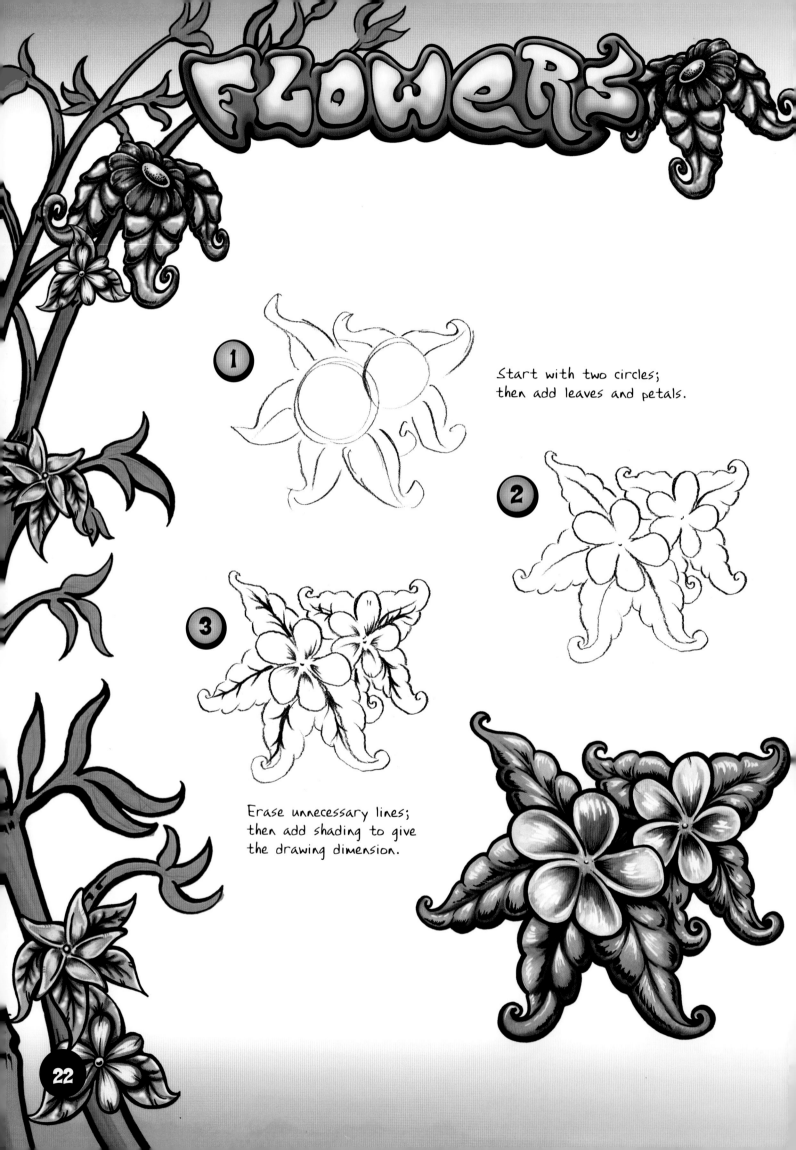

1 Start with two circles; then add leaves and petals.

2

3 Erase unnecessary lines; then add shading to give the drawing dimension.

22

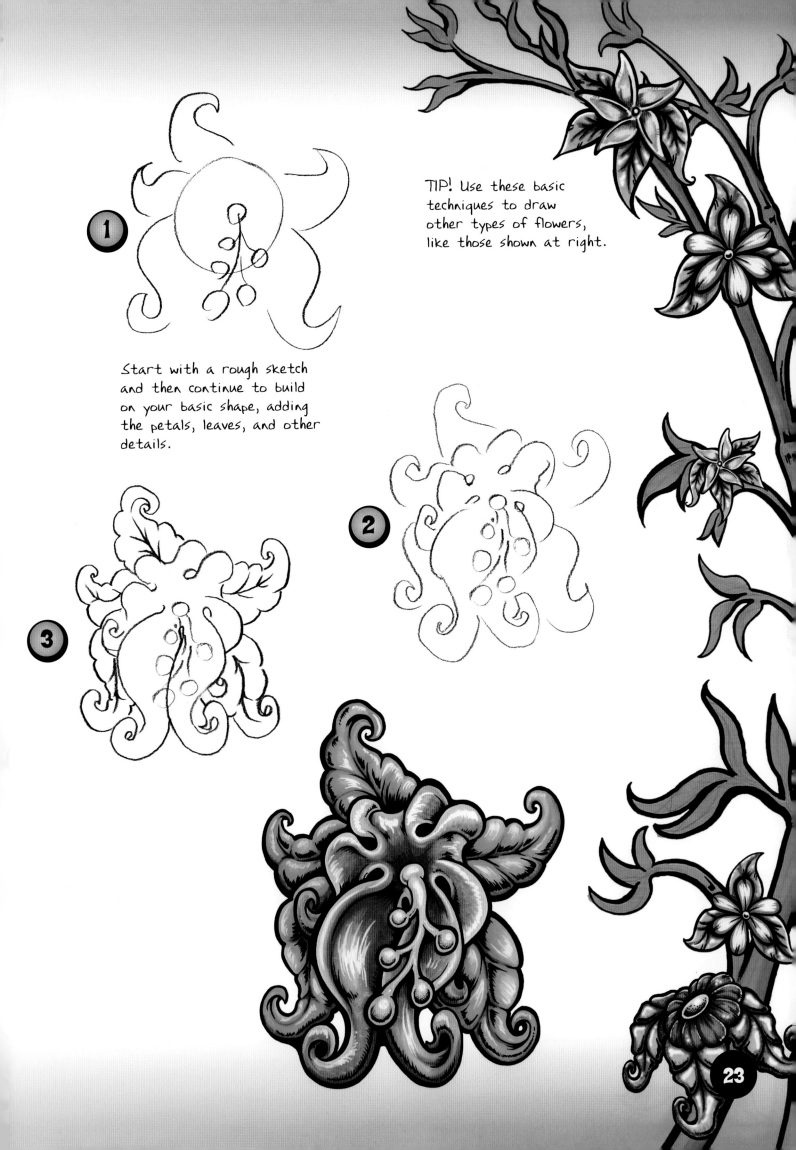

1

TIP! Use these basic techniques to draw other types of flowers, like those shown at right.

Start with a rough sketch and then continue to build on your basic shape, adding the petals, leaves, and other details.

2

3

① FLOWERS

② FLOWERS

FLOWERS

BAMBOO

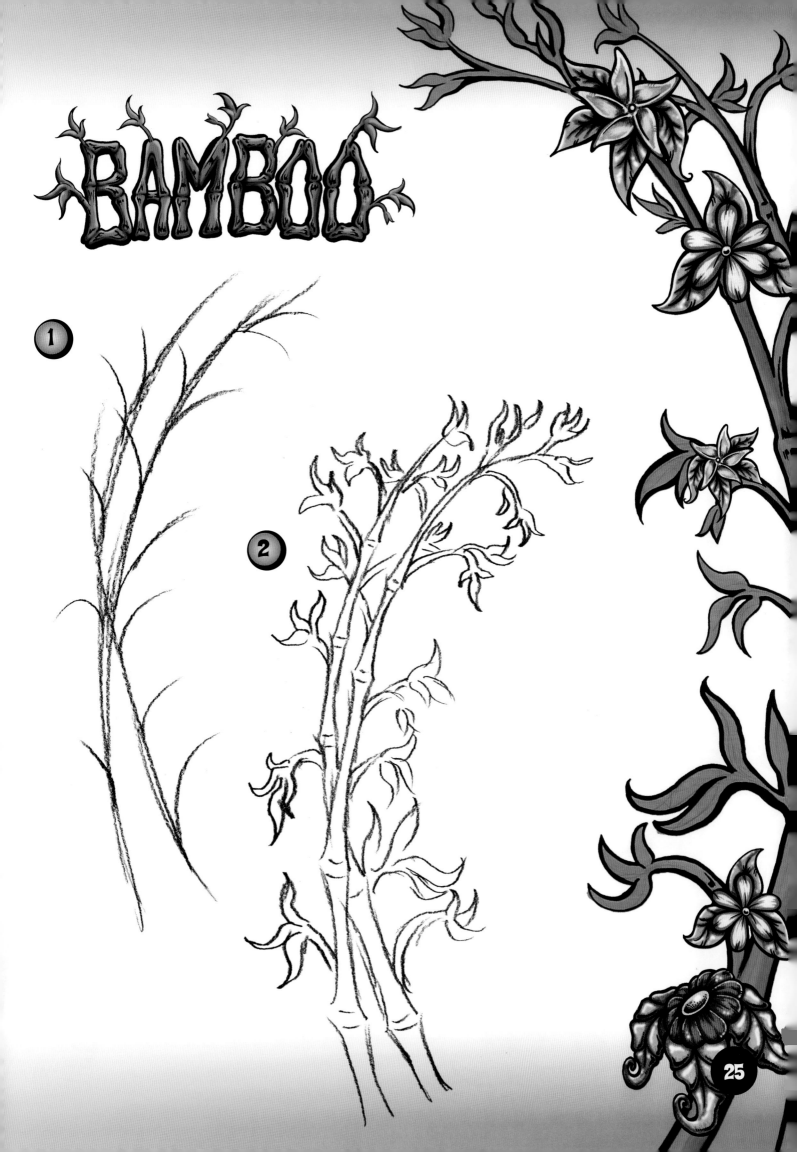

1

2

BUGS

1

Start with overlapping ovals for the eyes.

2

Draw a series of half circles to create the body.

3

Add the antennae, the "nose," and wing detail.

Bring this butterfly to life by using bright colors and adding high-lights in select areas (see pages 6-7). Then outline the drawing in heavy black.

1

2

3

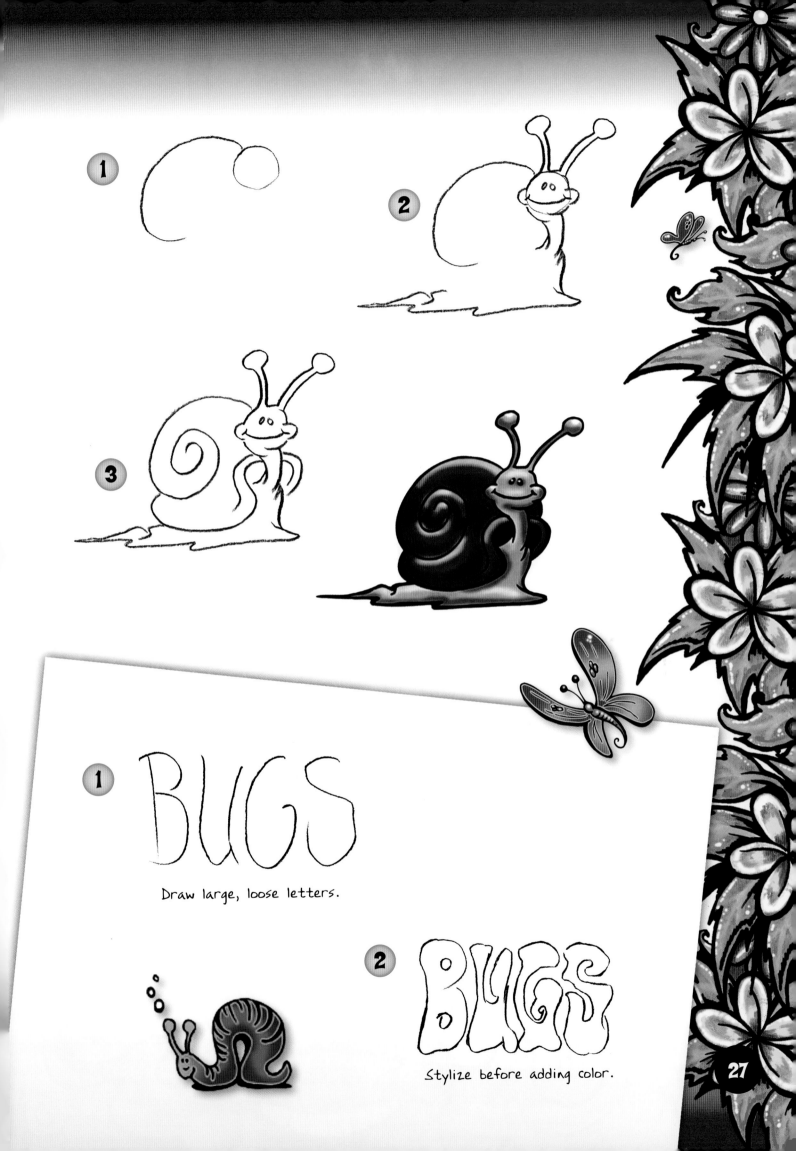

1 BUGS

Draw large, loose letters.

2 BUGS

Stylize before adding color.

SUN

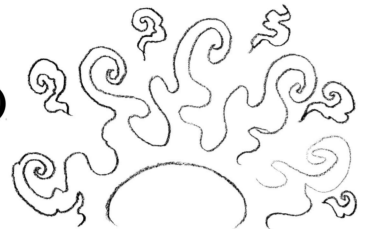

1 Start with a half oval and some squiggly lines for the rays.

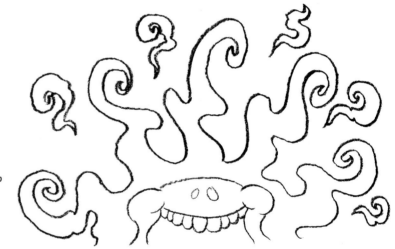

2 Add eyes, teeth, and cheeks.

Bright, white teeth and dimples make this sun extra happy.

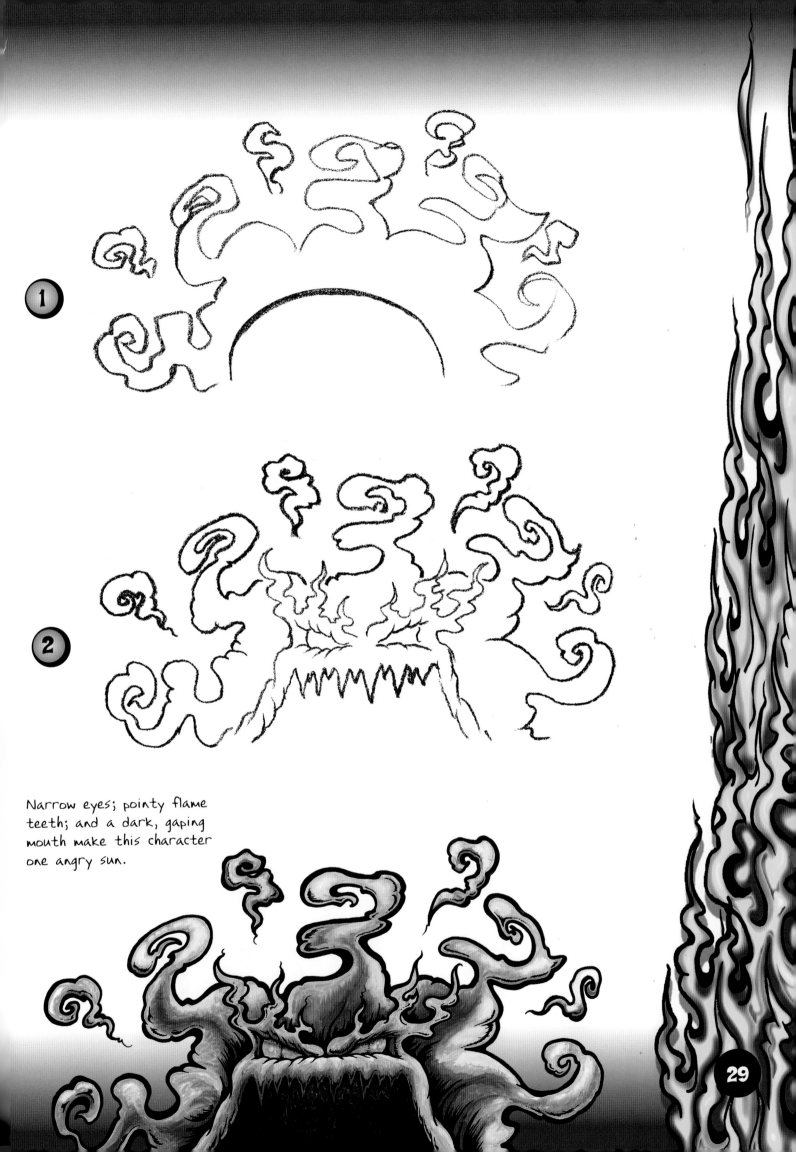

1

2

Narrow eyes; pointy flame
teeth; and a dark, gaping
mouth make this character
one angry sun.

Flames

TIP! Get creative with color. These are your drawings, so anything goes.

1 FLaMES

2

1 Start with a loose, flowing sketch.

2 Clean up your lines.

Bright yellow, deep red, orange, and white highlights give this flame its fire.

FLYING EYEBALL

Start with a piece of tracing paper folded in half vertically, with the crease facing right. Sketch half of the eyeball and wing against the edge of the crease. Next, with the page still folded, flip the paper over so that the crease is now facing left. Trace over your first sketch onto the opposite side of the page.

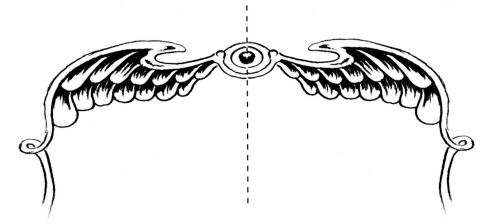

Unfold the paper to reveal the top part of the drawing. Now fold the bottom half of the paper horizontally under the top. Flip the paper over and repeat the steps above to create the bottom "reflection."

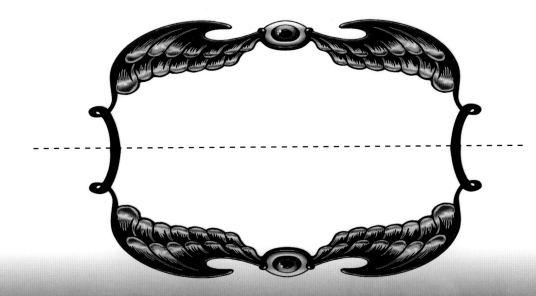

31

Skull & Crossbones

Bandana

Mean eyes

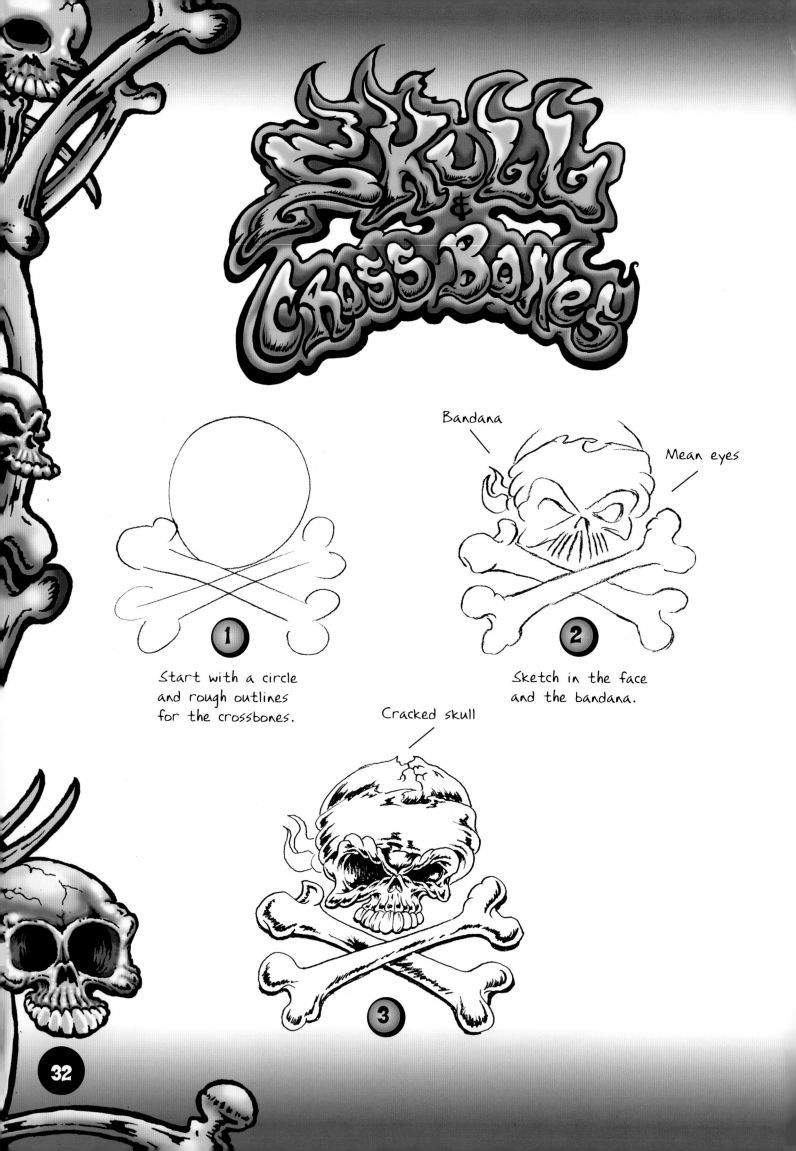

1 Start with a circle and rough outlines for the crossbones.

2 Sketch in the face and the bandana.

Cracked skull

3

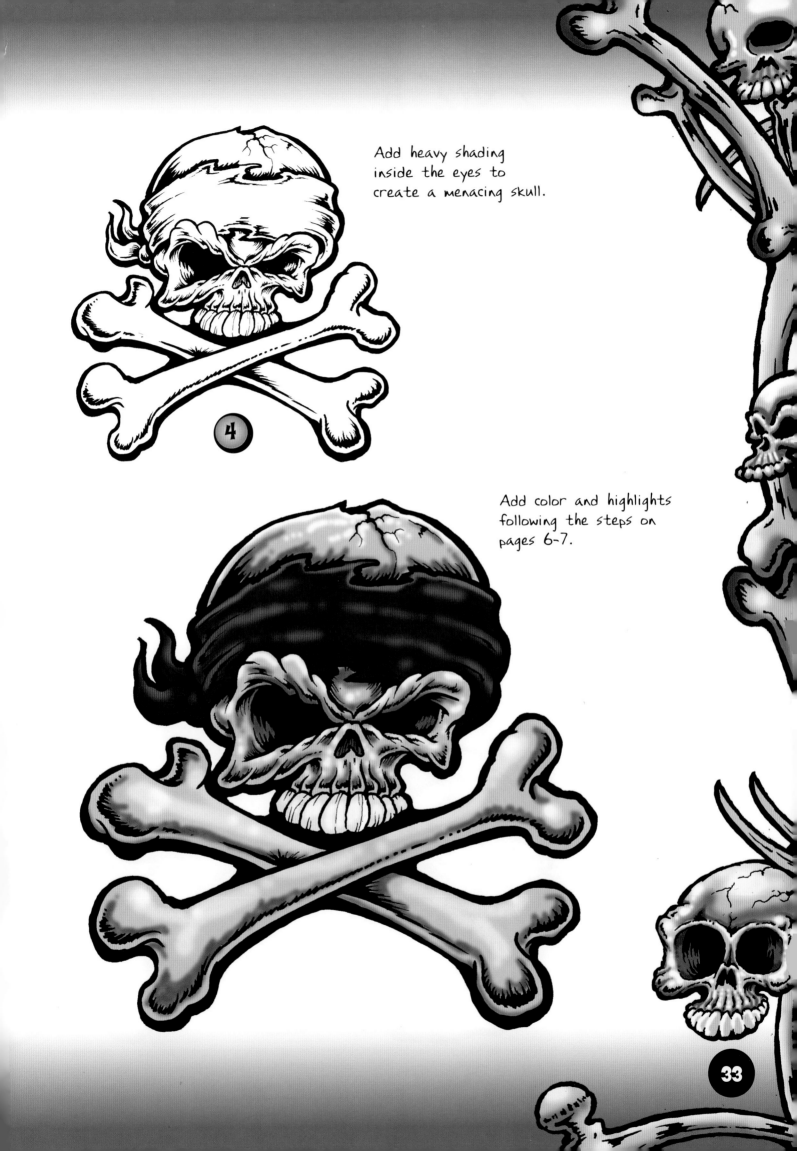

Add heavy shading
inside the eyes to
create a menacing skull.

④

Add color and highlights
following the steps on
pages 6-7.

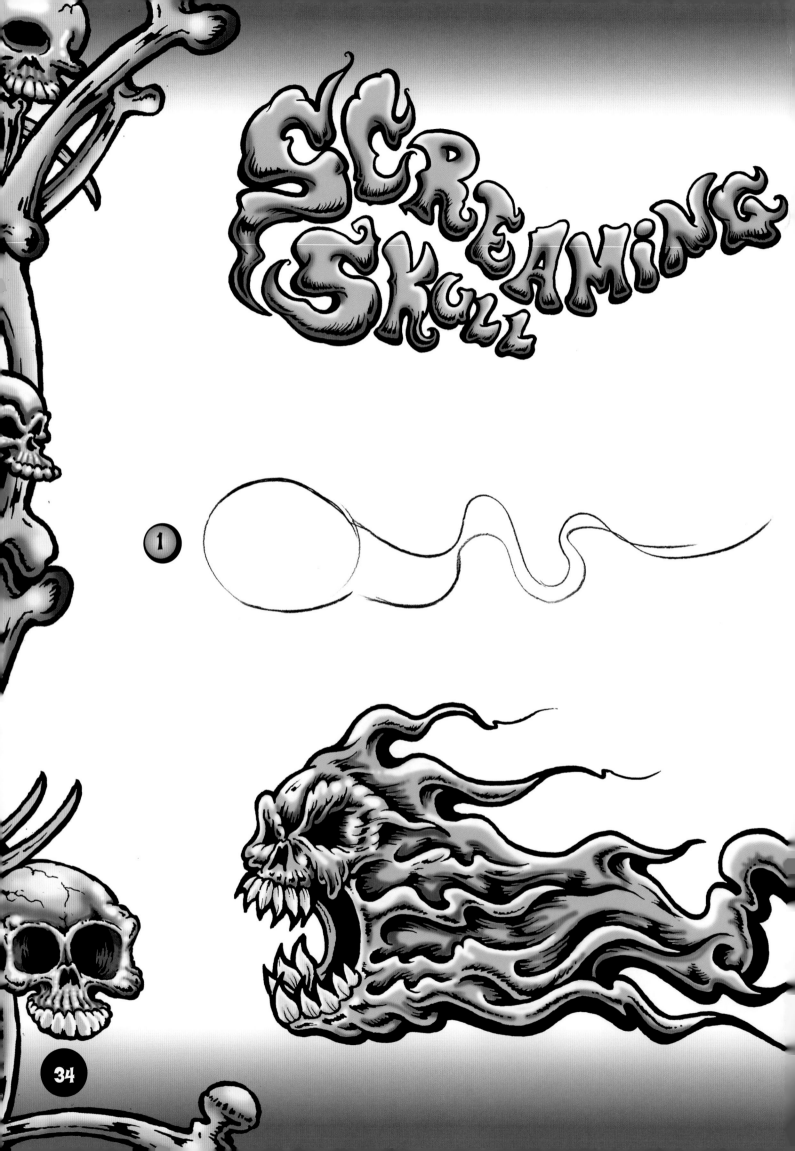

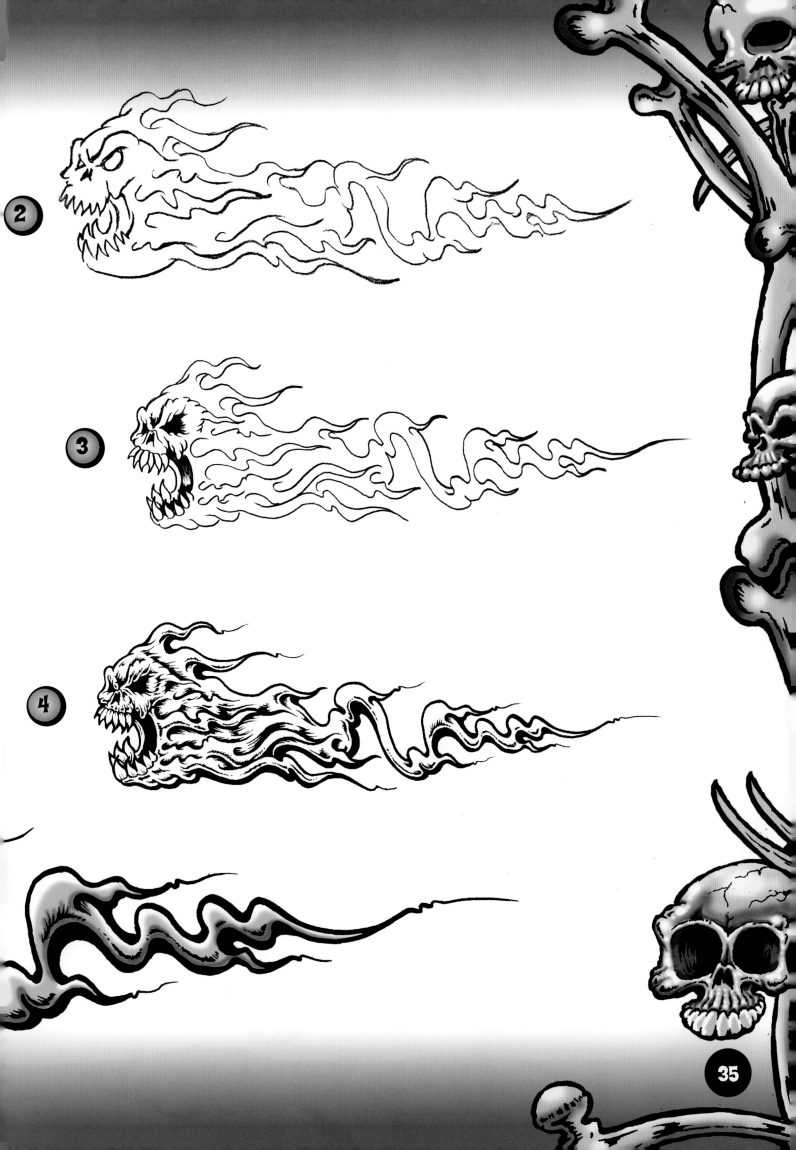

2

3

4

At the Beach

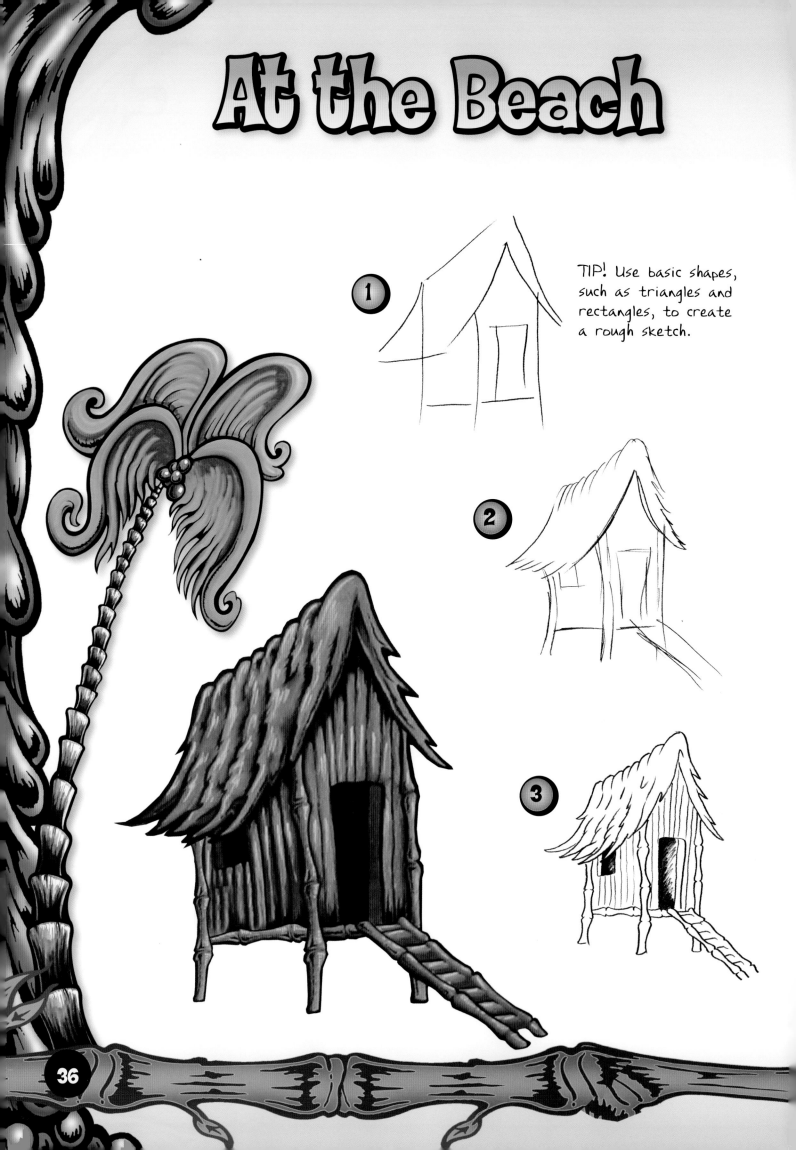

1

TIP! Use basic shapes, such as triangles and rectangles, to create a rough sketch.

2

3

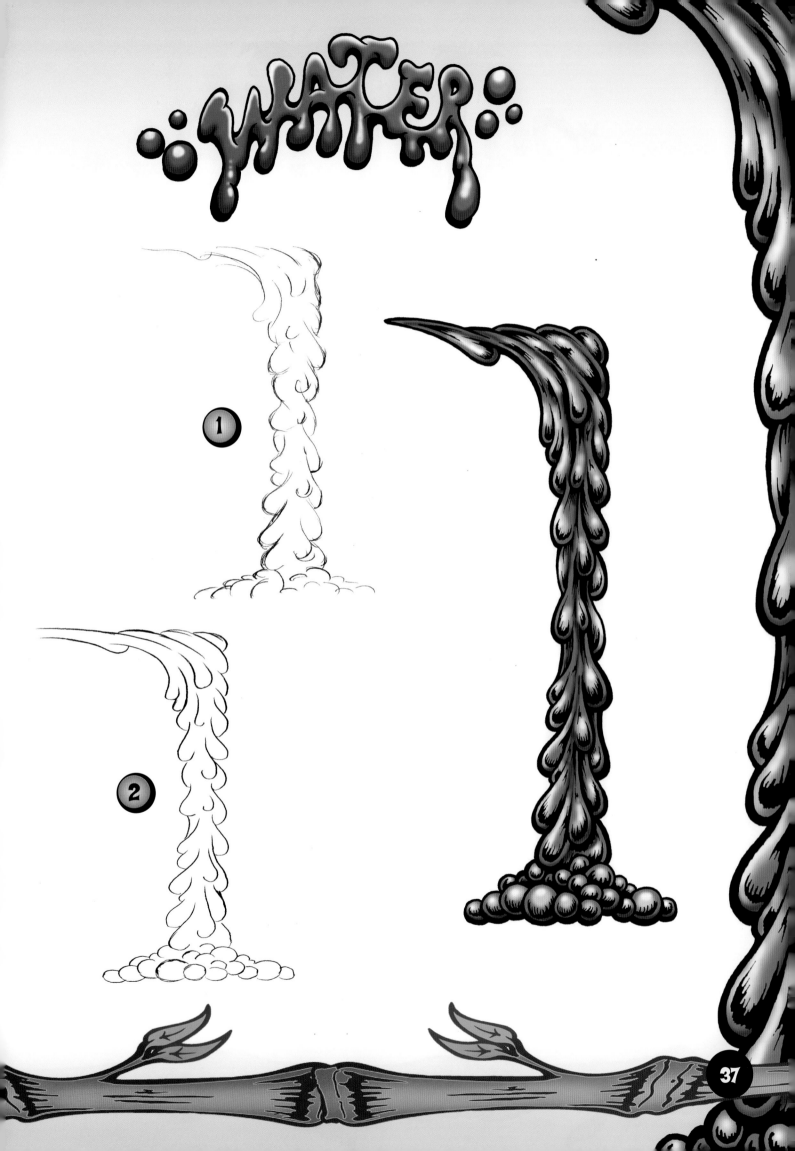

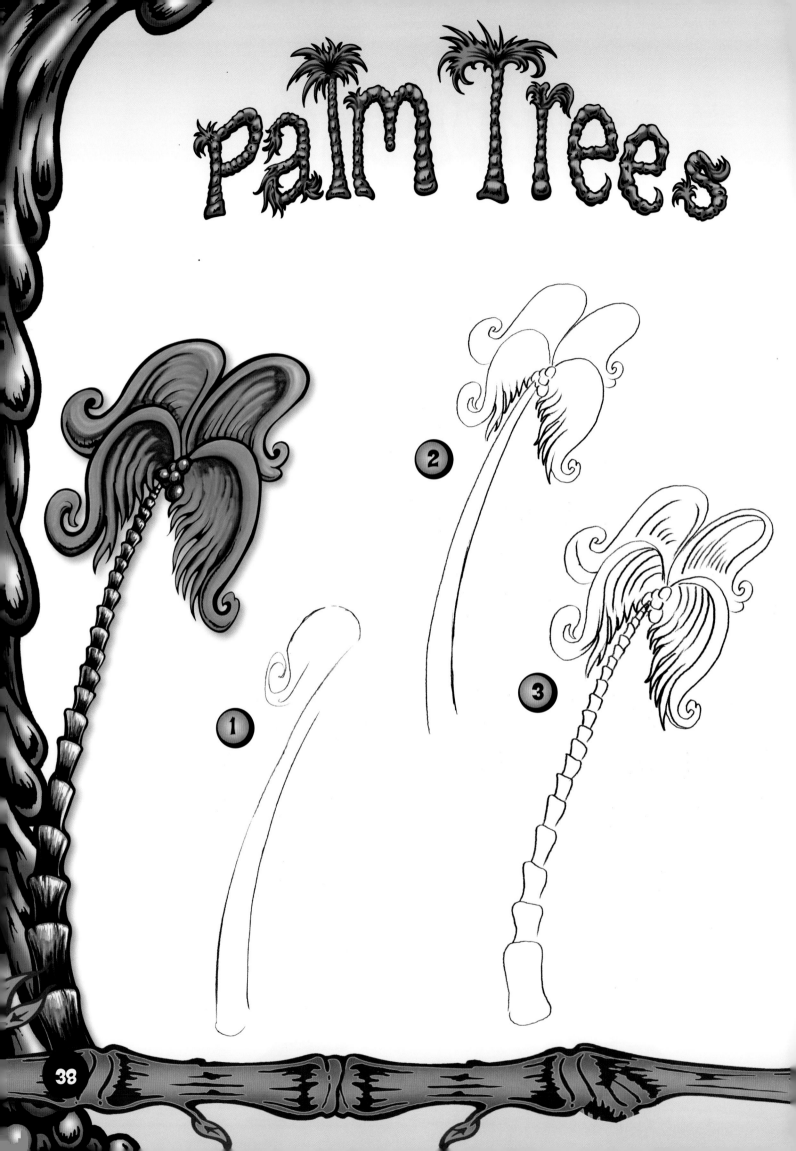

Palm Trees

1

2

3

① Palm Trees

② Palm Trees

③ Palm Trees

TIP! Don't worry about making your drawing "perfect." Just do what feels natural to you.

Drew in the Studio

Now that you've drawn the individual elements, try putting some of them together to create one big sketch. Then use your sketch as a map to add color to one section at a time. Before you know it, you'll have an incredible piece of art!

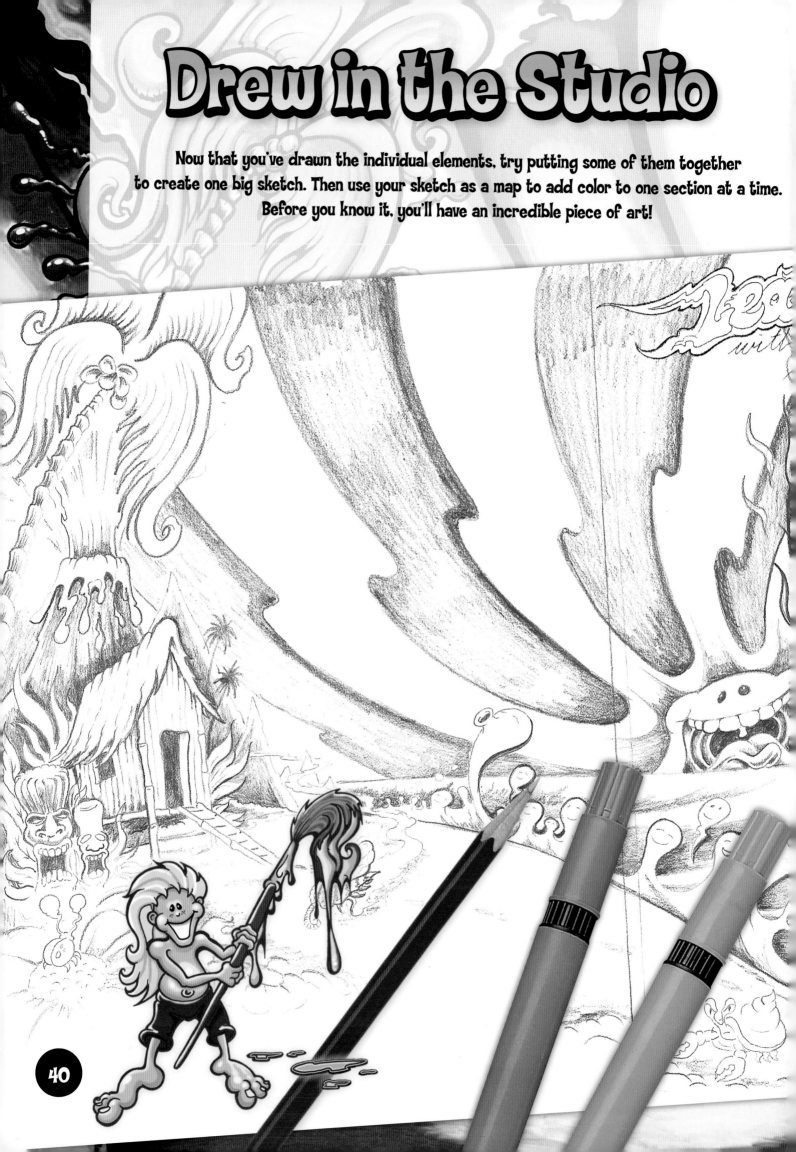

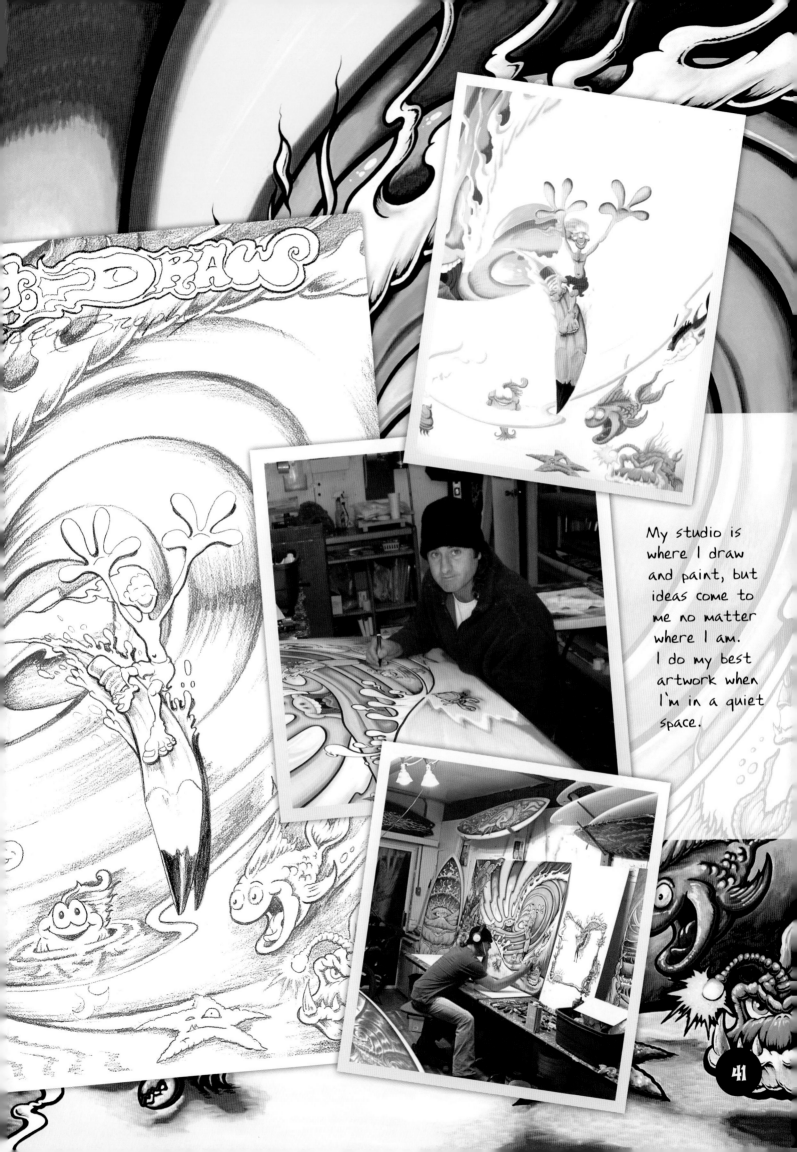

My studio is where I draw and paint, but ideas come to me no matter where I am. I do my best artwork when I'm in a quiet space.

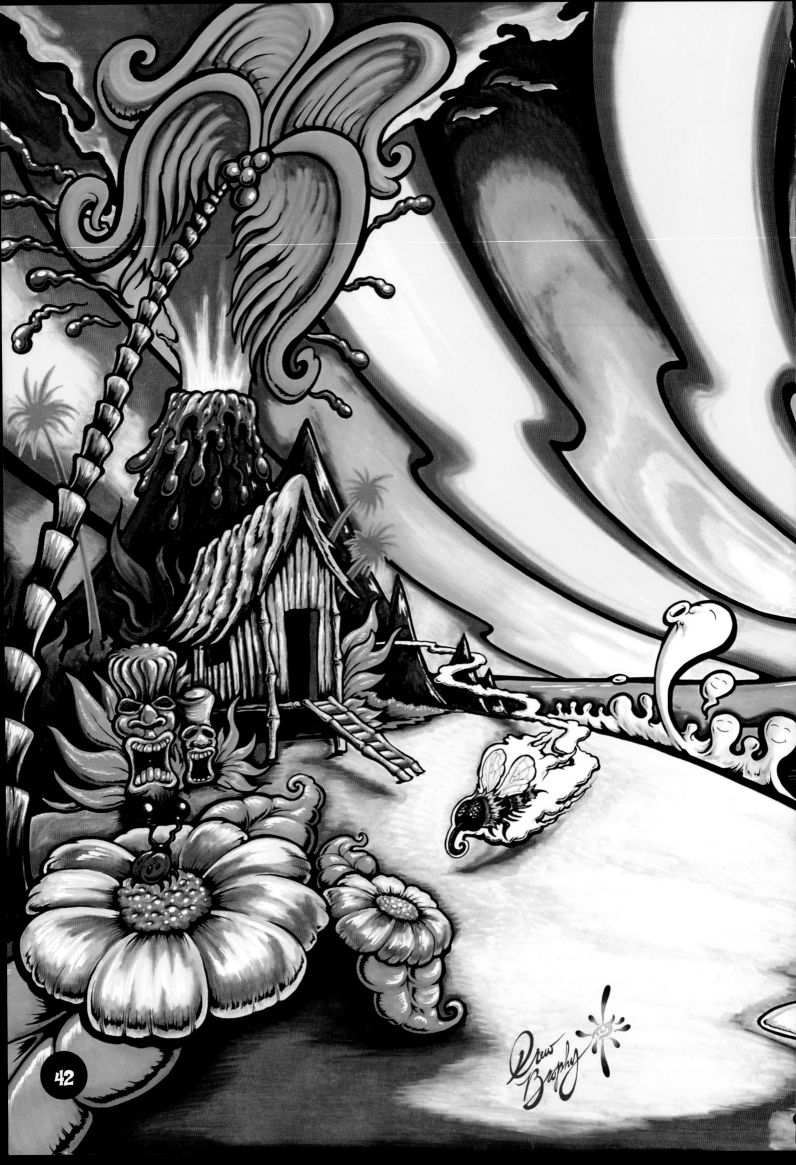

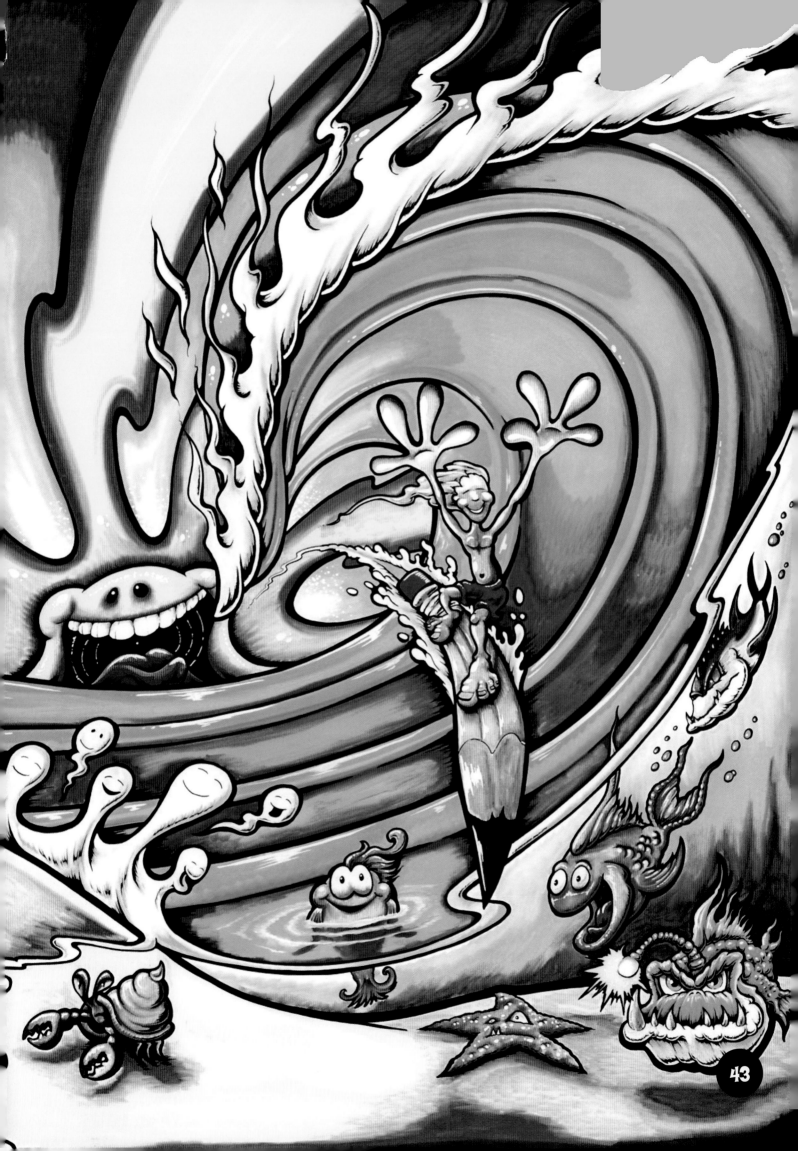

Customize Your Gear

I've always painted my guitars, skateboards, and surfboards. Over the years, I've customized just about everything, from snowboards and canvas shoes to vans, helmets, and motorcycles. You can customize your own gear, too. My drawing and painting techniques make the process easy because I follow the same steps every time I paint. You can apply color using waterproof markers, acrylic paint, or water-based paint pens (see pages 6-7). I prefer water-based paint pens (an opaque medium).

Step 1
Sketch your design in pencil first, creating a composition where all of the elements flow into one another. Decide which color combinations you are going to use before you start adding color.

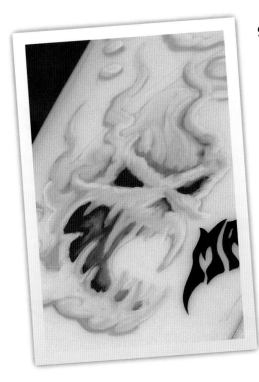

Step 2
Starting with the lightest color combination first, paint a small section at a time. I start with light blue and white for the Screaming Skull (see page 34). Then add dark blue to emphasize the mouth, eyes, and nose.

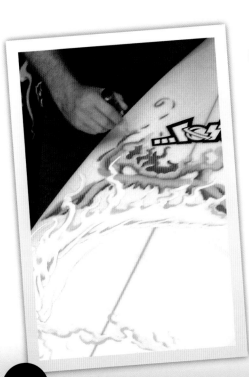

Step 3
Add the next lightest color combination. I paint the sun using red first; then I blend orange into yellow in small sections.

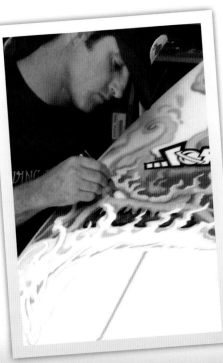

Step 4
Next, add the more intricate details with your preferred colors. I color the sun's eyes green and the open mouth dark purple (see page 29).

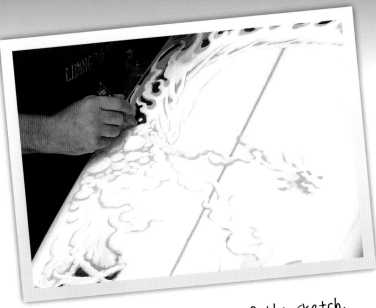

Step 5 Now fill in the rest of the sketch. I use dark blue, black, and purple for various details. Then I paint the top of the wave light blue, blending into dark blue (see pages 8-9).

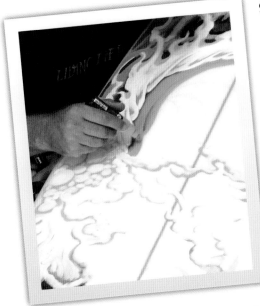

Step 6
For the inside of the wave, I use light green, blending into the light blue and dark blue.

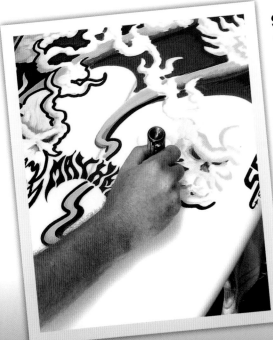

Step 7
With the color completed, I outline the entire painting in heavy black, using both thin lines and thick lines where I want to give more emphasis. I also add highlights in white to make the painting pop.

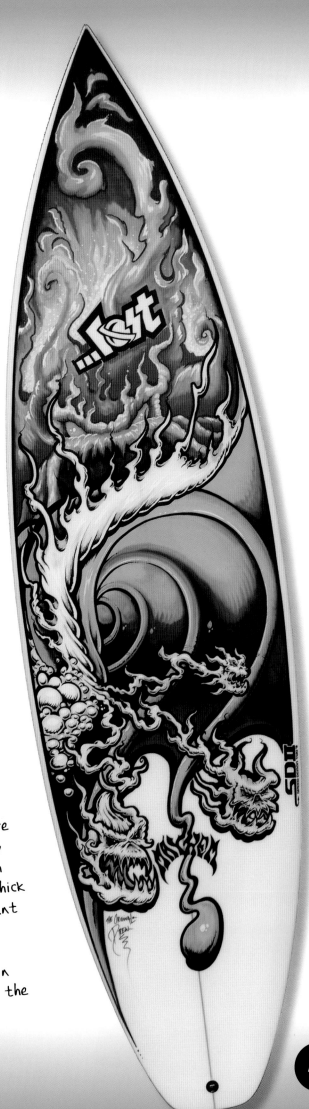

Step 1 Sketch your design in pencil on the deck of the skateboard (I draw a flaming eyeball). Then select your color scheme.

Step 2 Paint the lightest areas first. I start with the white of the eye; then I apply light blue to the water bubbles. I also give the bubbles dimension by adding a dark blue outline around the lower edge.

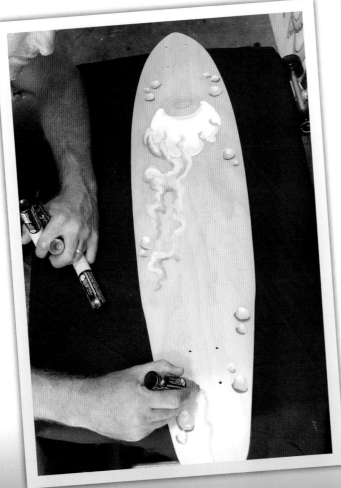

Step 3 Next, I paint the flames yellow and outline them in red. I add orange along the edges blending into the yellow. Keep your grip on your painting tool loose and relaxed as you fill in the color.

Step 4 I add light green for the eye, blending into darker green. Then I paint the background stripes. First I outline each stripe in black; then I apply color, starting with dark purple at the top and painting every other stripe.

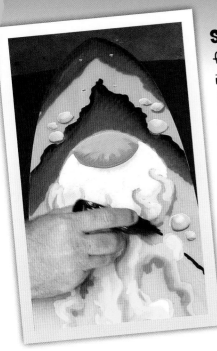

Step 5 Next I paint the rest of the background stripes dark blue.

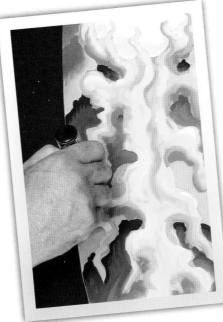

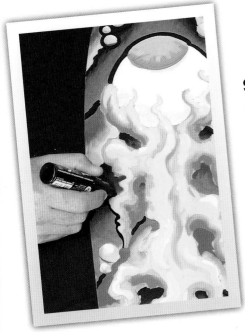

Step 6 When the color is complete, I outline the entire painting in black, starting with thick lines and working down to thin lines.

Step 7 Finally, I add shading in places to give the painting dimension. I finish the details and add white highlights.

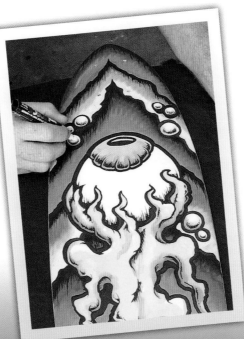

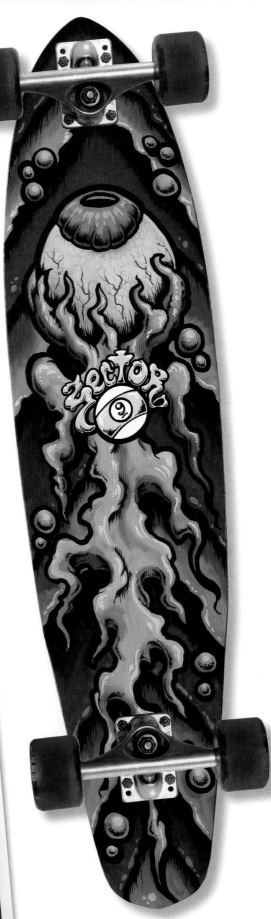

I hope my book inspires you to create more art. Drawing can be a lot of fun when you keep it loose and free and when you draw without limitations. Let your drawings grow into fantastic ideas and allow your dreams to spill out onto paper. You'll be surprised at what you'll come up with! I took my love for drawing and made it into my full-time job where I get to make things look cool. And you can, too. Learning to draw can lead to many great careers. And they all start with an idea and a sketch.

P. S. I want to see what you create! Send your drawings to me at drawing@drewbrophy.com. And for more art tips, visit www.drewbrophy.com.

LIFE IS GOOD!

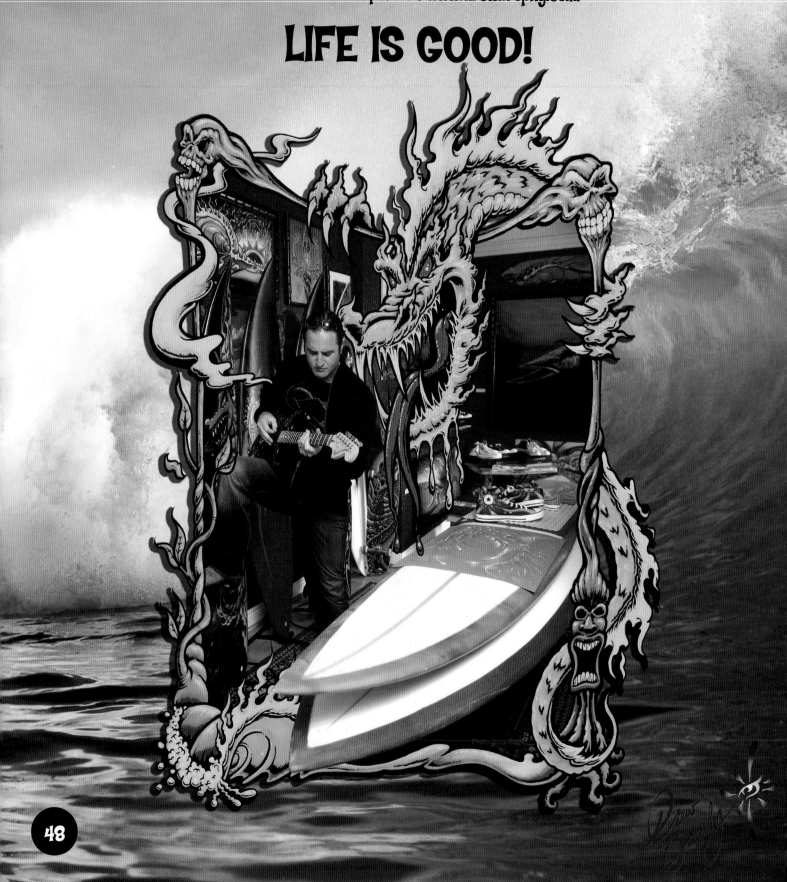